A TALE OF HEART & MAGIC

# BIG MONSTER

Juliette Crane

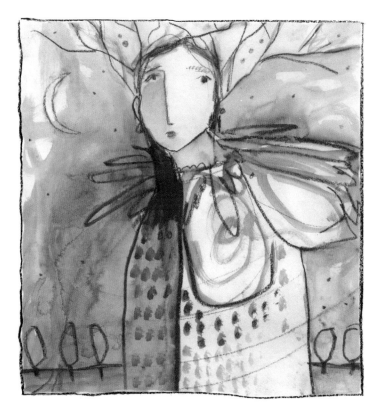

This book is for anyone who has ever felt different or unimportant.

And to Brian, who has helped me know the difference.

You know when there's a monster in your closet

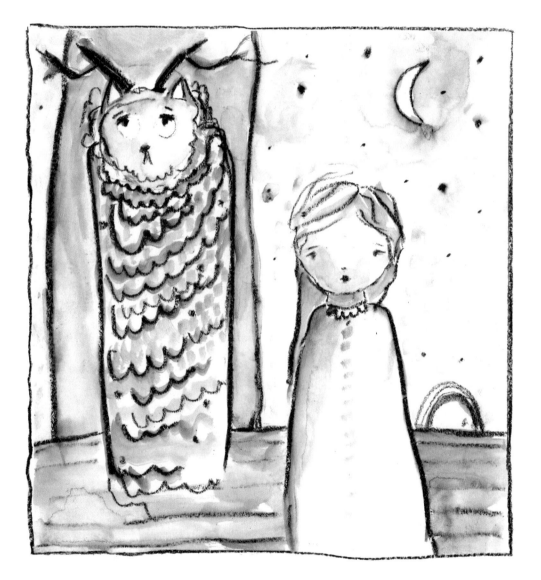

except no one can see him but you.

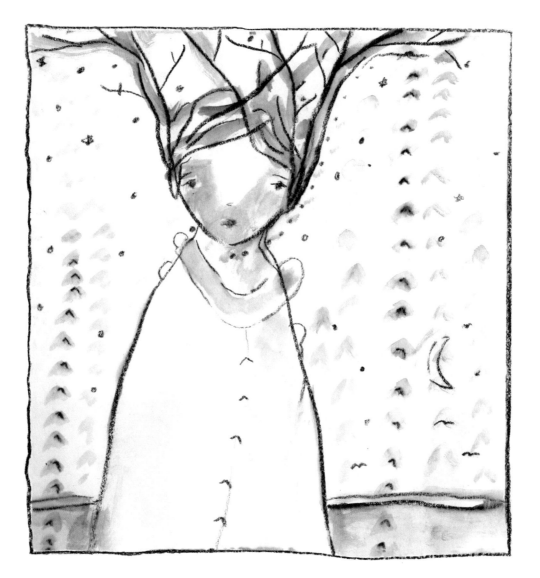

He's big

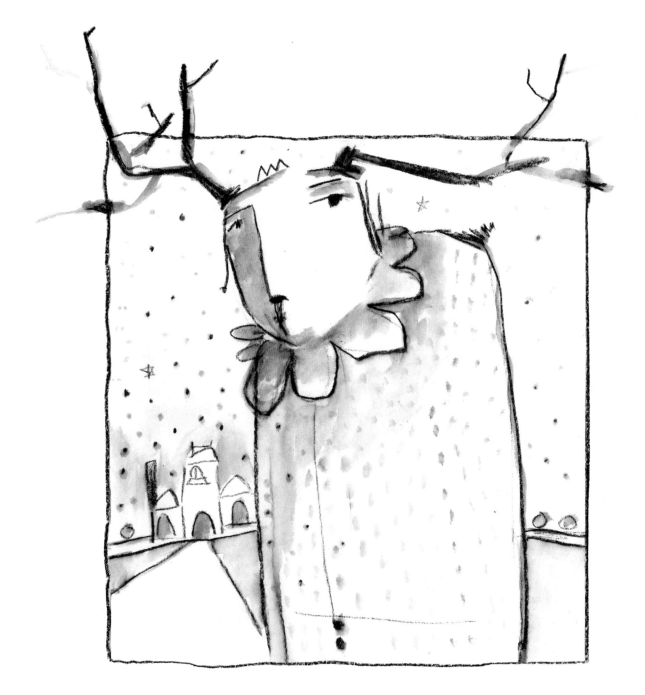

and hairy

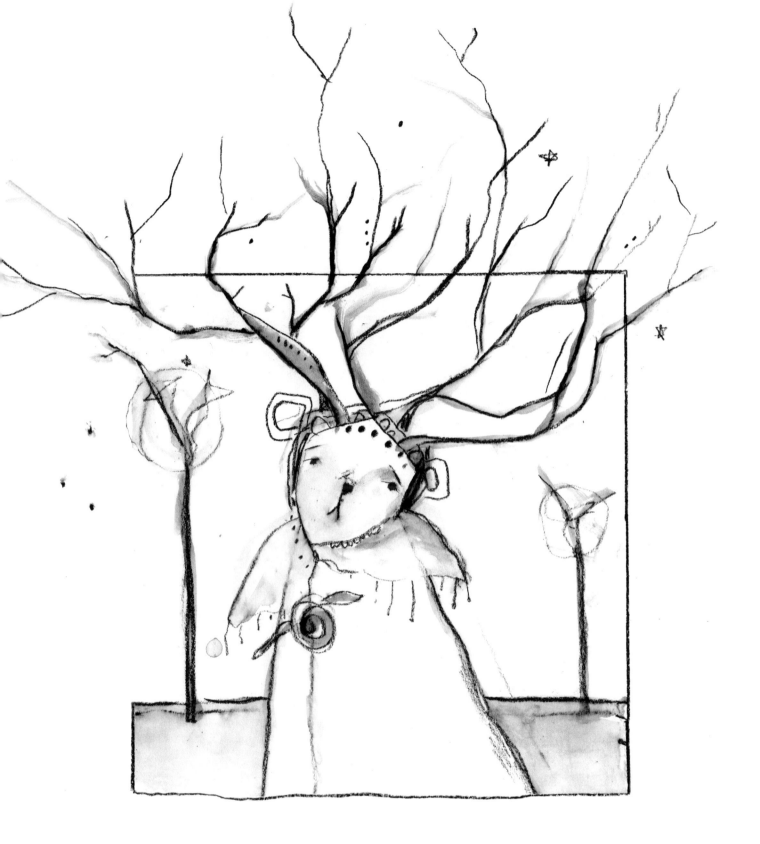

with giant shark teeth

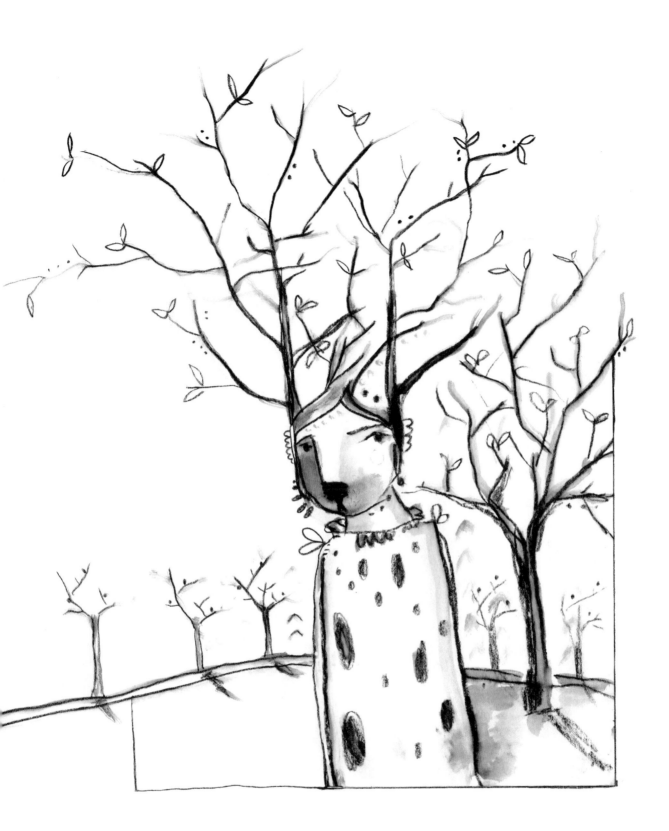

and big, long claws.

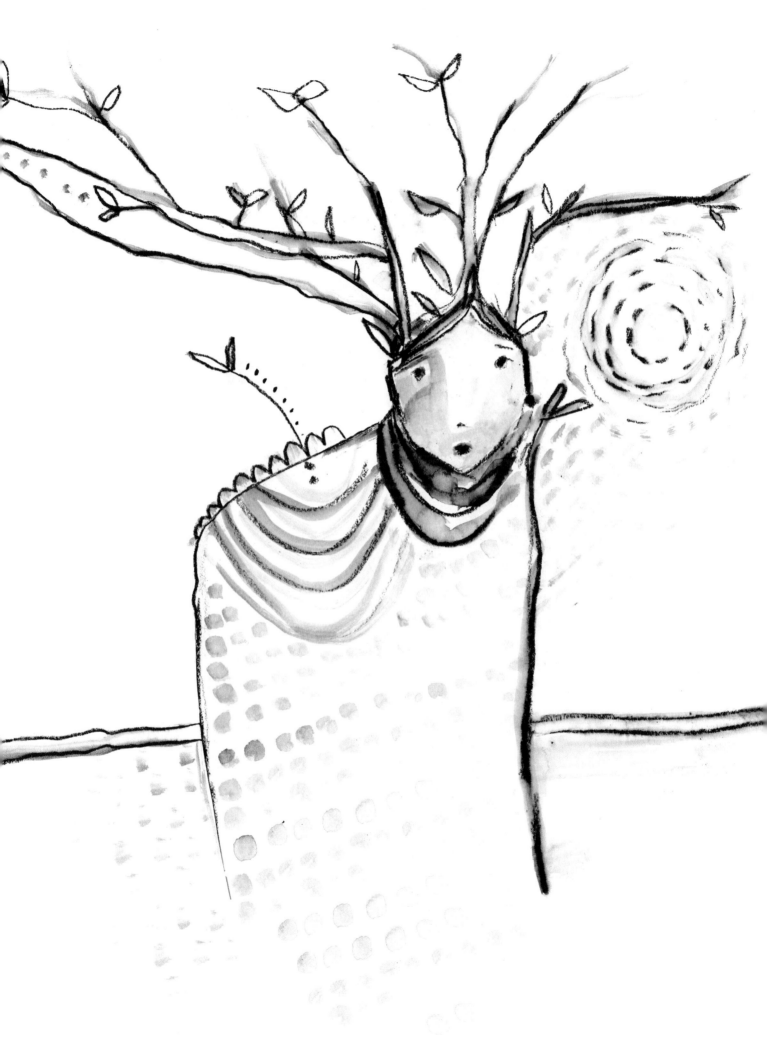

But the kindest eyes.

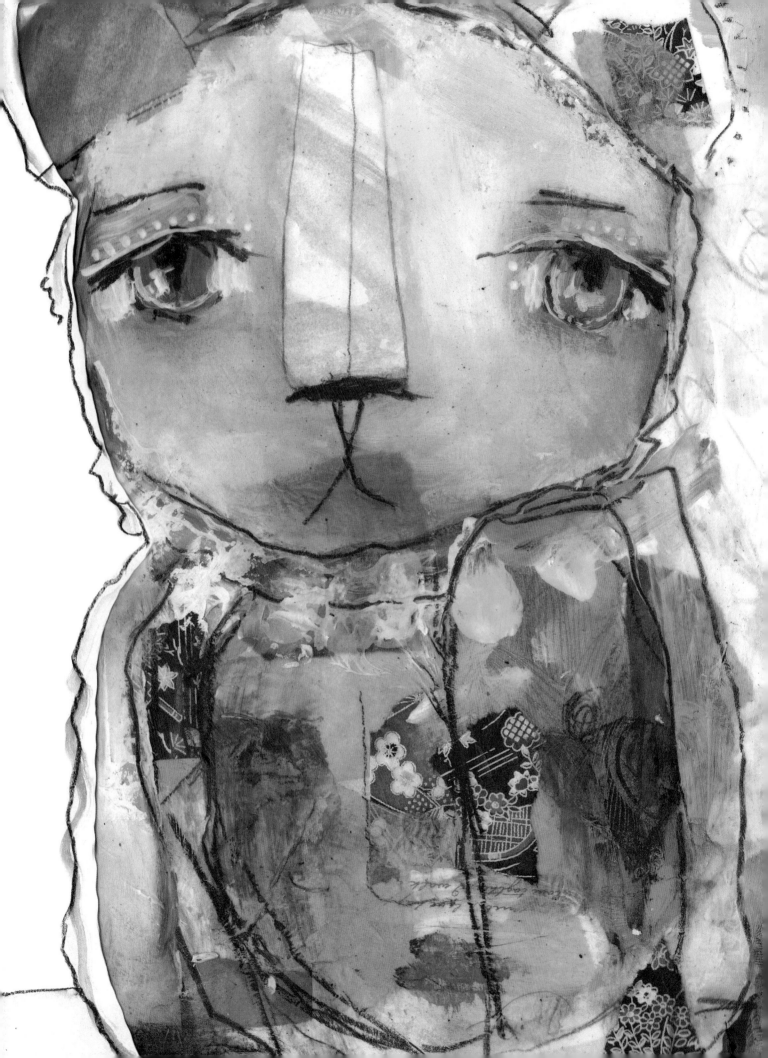

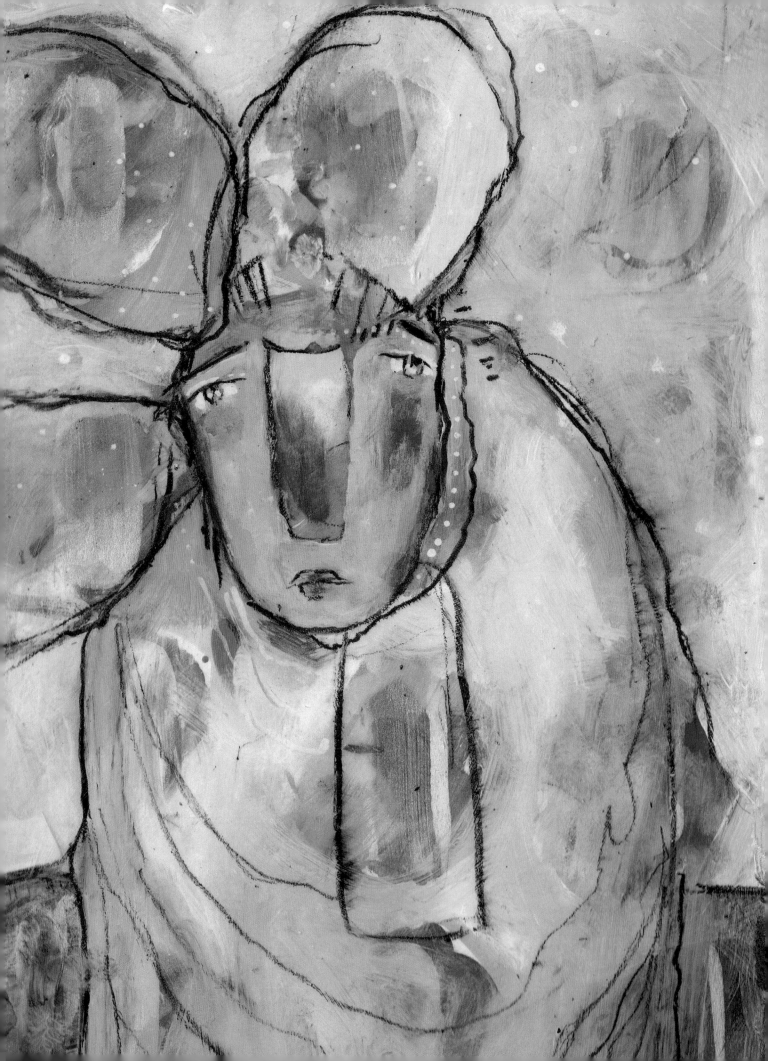

You can't help but go up to him

and ask him to be friends.

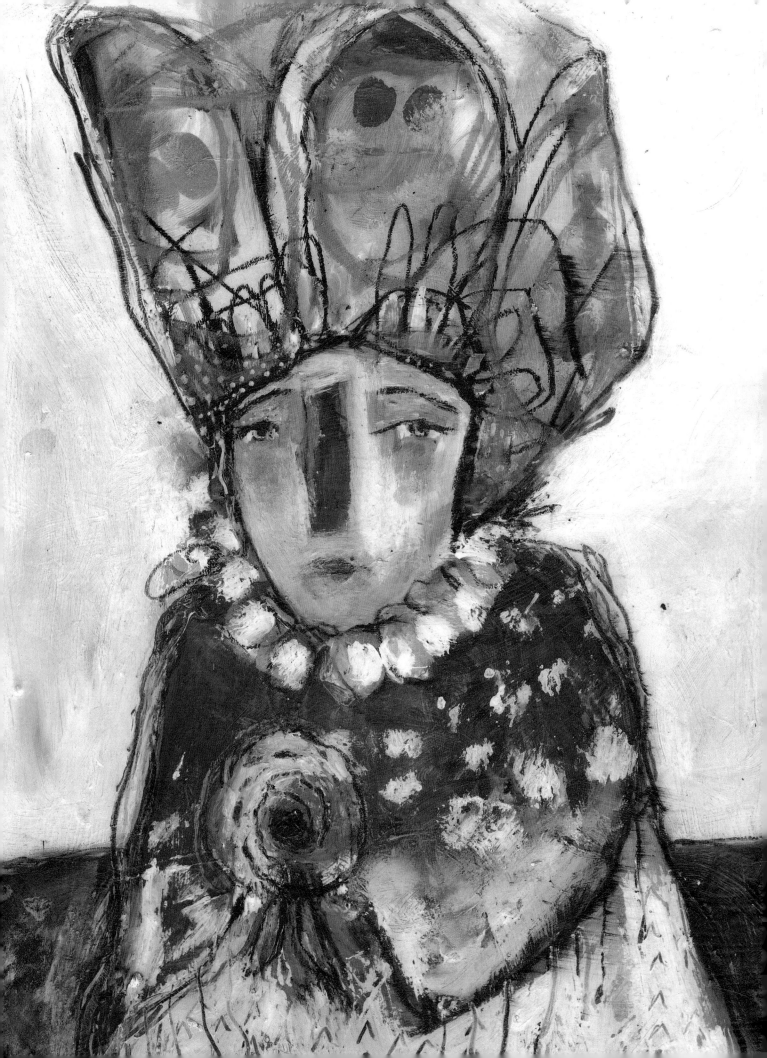

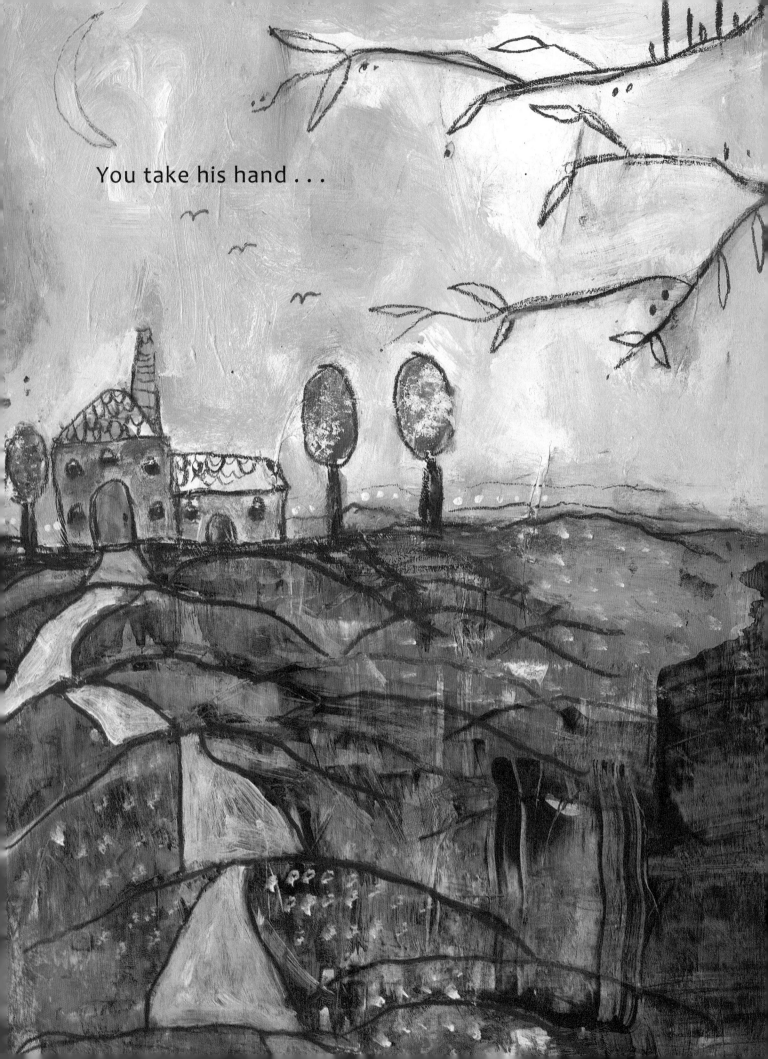

You take his hand . . .

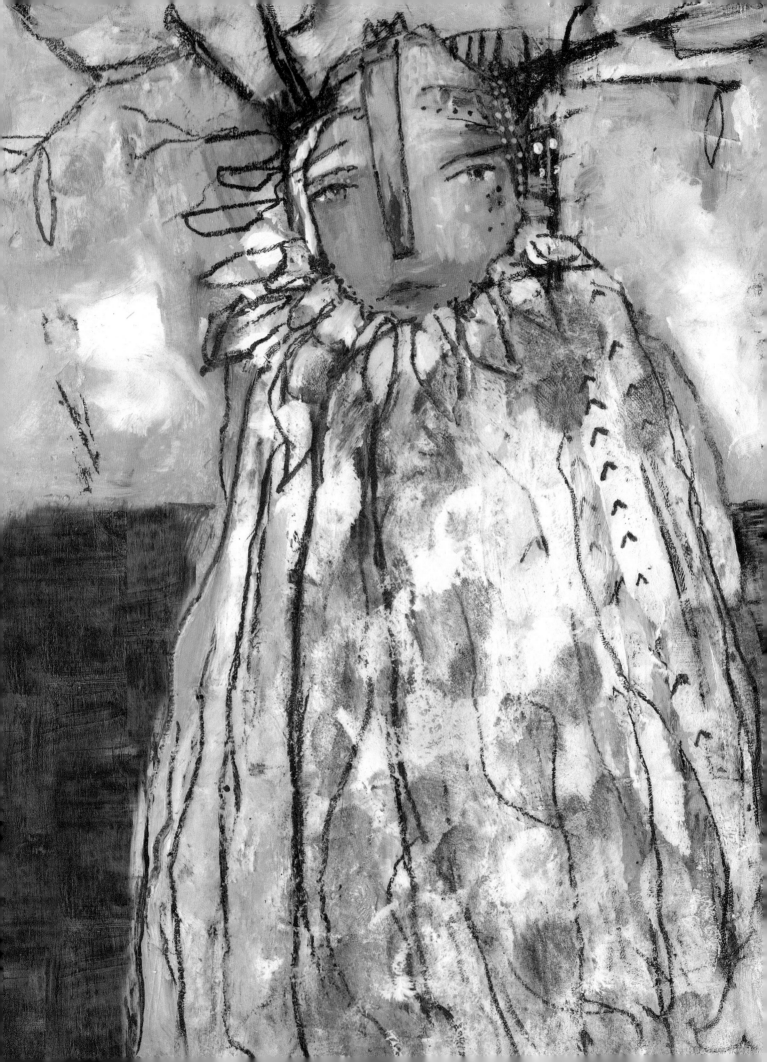

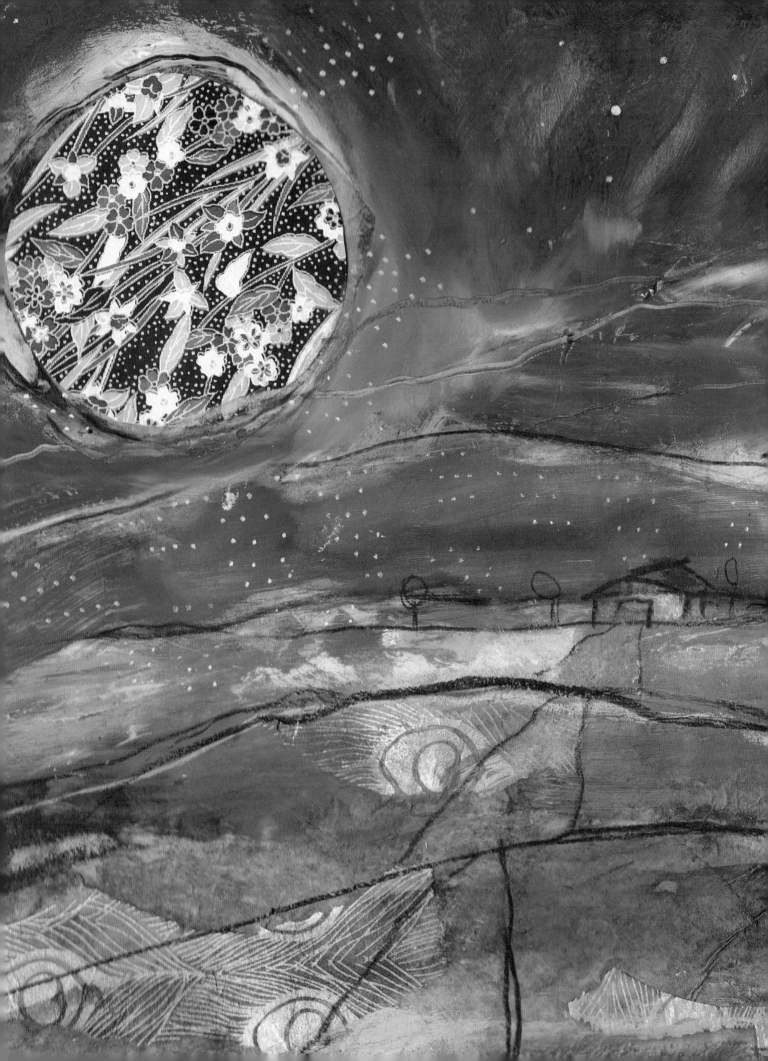

. . . and he shows you where he lives.

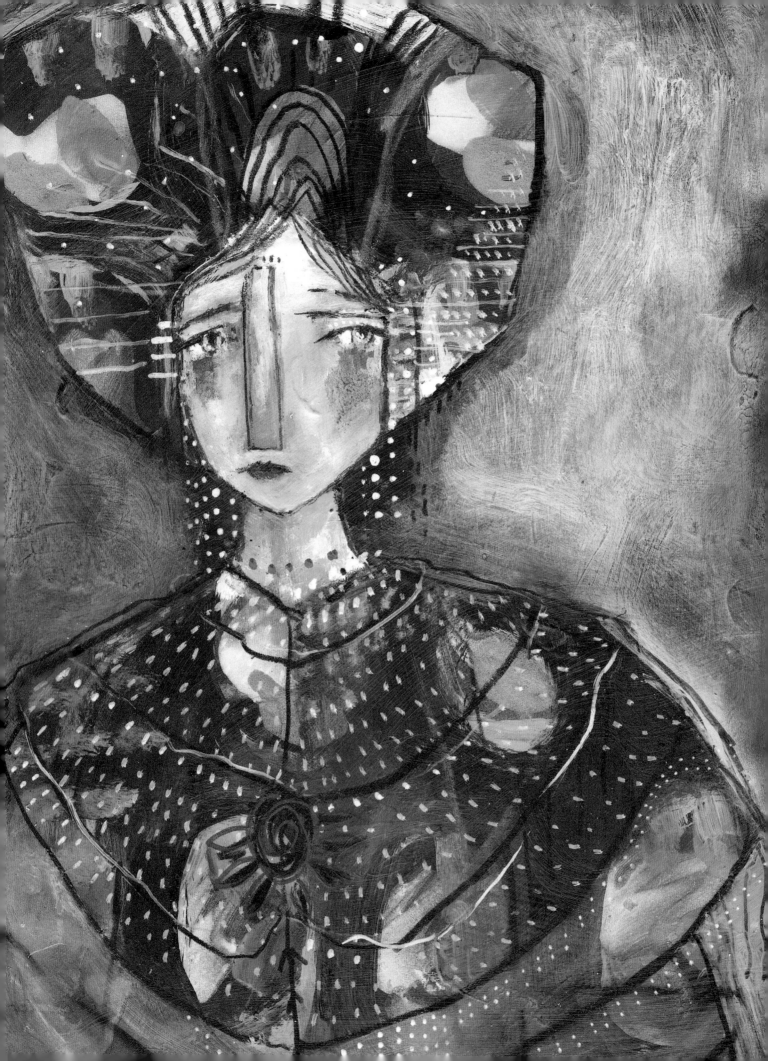

He takes you into the woods
and to his grandmother's house

which is a cute little cottage
at the edge of the forest.

You never imagined...

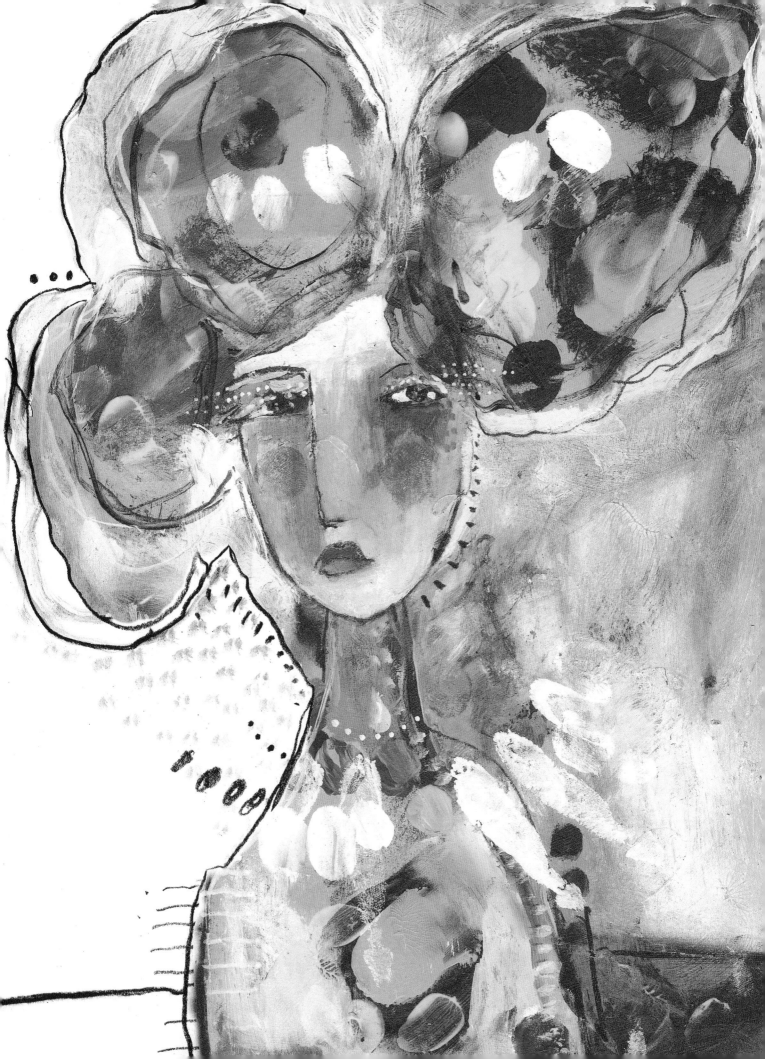

that such a monster

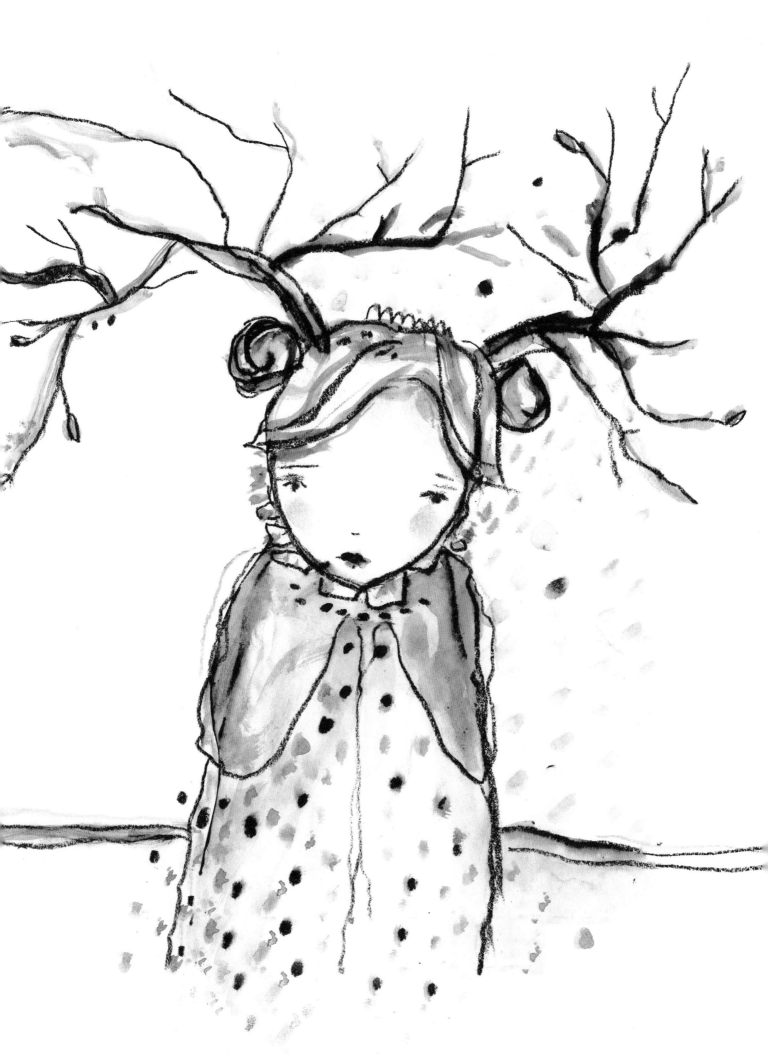

would come from a beautiful place.

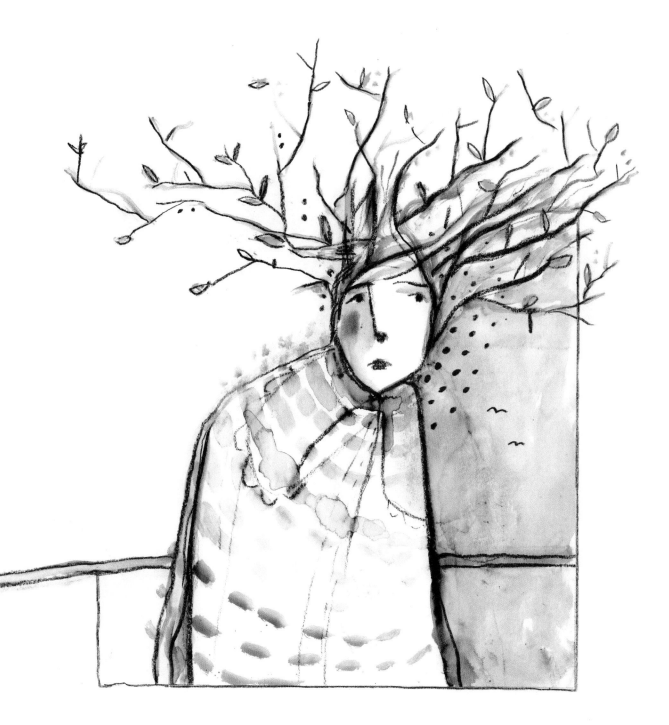

And all of a sudden you realize . . .

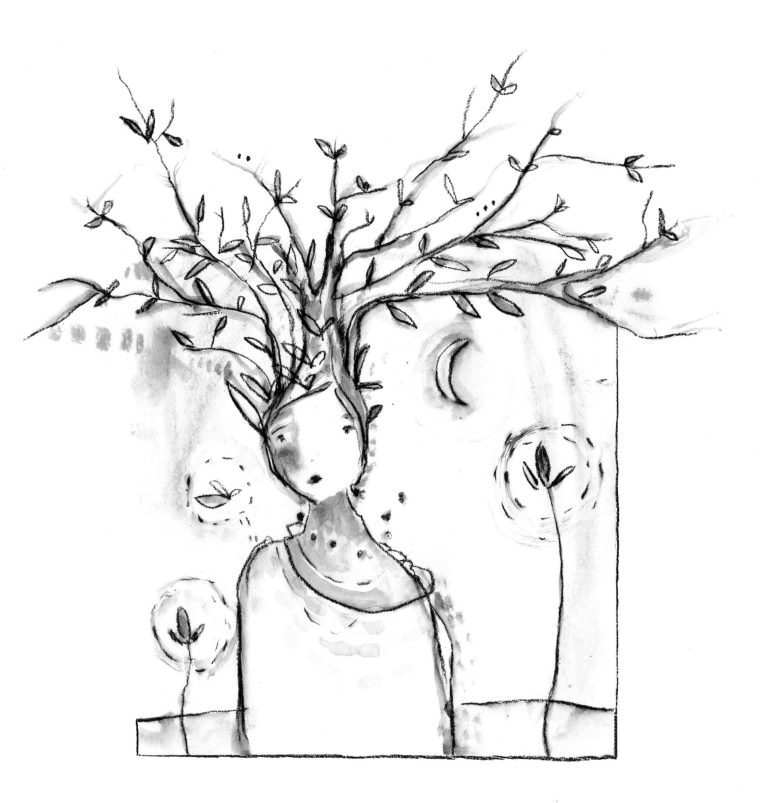

this monster is not such a

BIG

hairy

ugly

*mean*

monster at all.

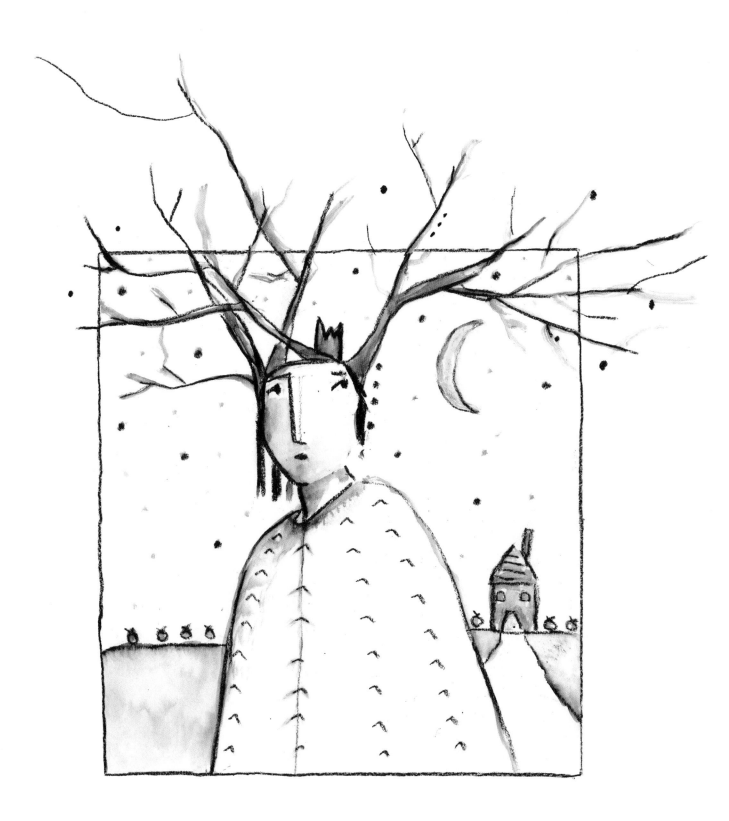

You just had to let him out of your closet . . .

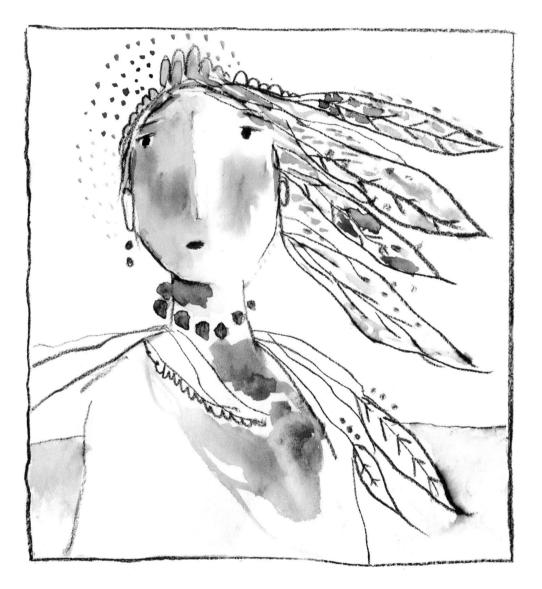

. . . and get to know him.

# About the Author

Juliette Crane is the creator of a series of painting workshops that help thousands around the world get creative and live their dreams. She is a full-time artist, storyteller and adventurer, spending as much time as possible painting outside and being inspired by the little things. Whenever she paints something it makes her happy, and her hope is that in sharing her art and stories, others might be inspired to share with the world whatever it is they're most passionate about too. Her work has been featured in Glamour Magazine, Oprah.com and Stampington & Company Publications.  Online painting classes and originals are available at **JulietteCrane.com**

The author would also like to acknowledge her husband, Brian Knapp, for his collaboration on this book.

The paintings in this book were made with all sorts of my favorite art supplies... some watercolors and pastels, pages from old books, maps and other pieces from my paper collection, lots of acrylics, pencil, pen and inks, and a bit of oils. Online painting classes and originals are also available at JulietteCrane.com

ISBN-13: 978-1518637940

Layout ©2015 by Brian Knapp
Text ©2015 by Juliette Crane
Artwork ©2015 by Juliette Crane
Author photo by Stephanie Claire Birr

The text of this book was composed in Candara and Chalet.
Published in 2015

**JulietteCrane.com**

Made in the USA
Charleston, SC
21 November 2015